NATURAL WONDERS
DOT-TO-DOT

CHARTWELL
BOOKS

Quarto is the authority on a wide range of topics.
Quarto educates, entertains, and enriches the lives of our readers—
enthusiasts and lovers of hands-on living.
www.quartoknows.com

This edition published in 2016 by
CHARTWELL BOOKS
an imprint of Book Sales
a division of Quarto Publishing Group USA Inc.
142 West 36th Street, 4th Floor
New York, New York 10018
USA

© 2016 Quarto Publishing Group USA Inc.

10 9 8 7 6 5 4 3 2

ISBN-13: 978-0-7858-3448-9

Printed in China

Puzzles by James Brisson
Cover and interior design by Melissa Gerber
Photo research by Dawn Cusick

CONTENTS

CHALLENGING....................................4

REALLY CHALLENGING 37

SUPER-DUPER CHALLENGING....................... 77

CHALLENGING ANSWERS107

REALLY CHALLENGING ANSWERS.................. 114

SUPER-DUPER CHALLENGING ANSWERS122

PHOTO ACKNOWLEDGMENTS.......................128

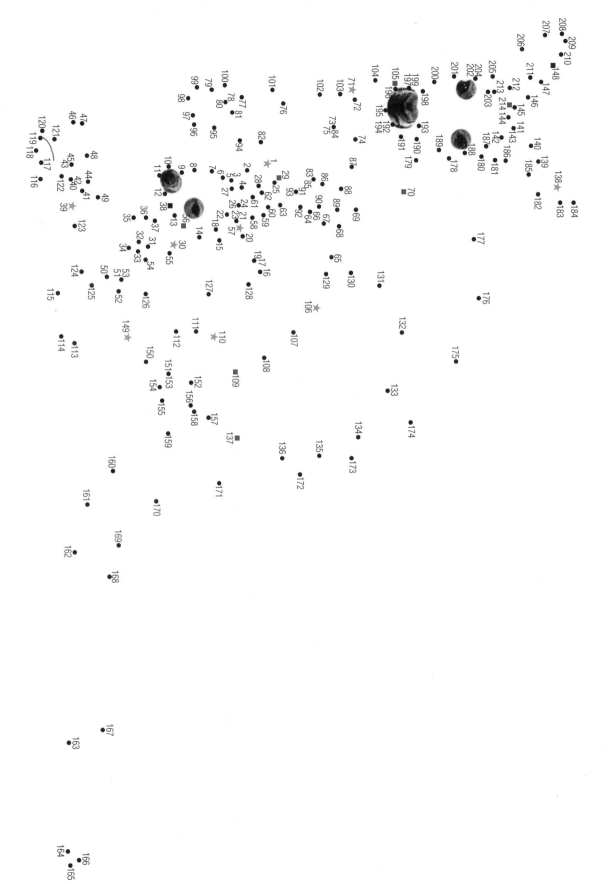

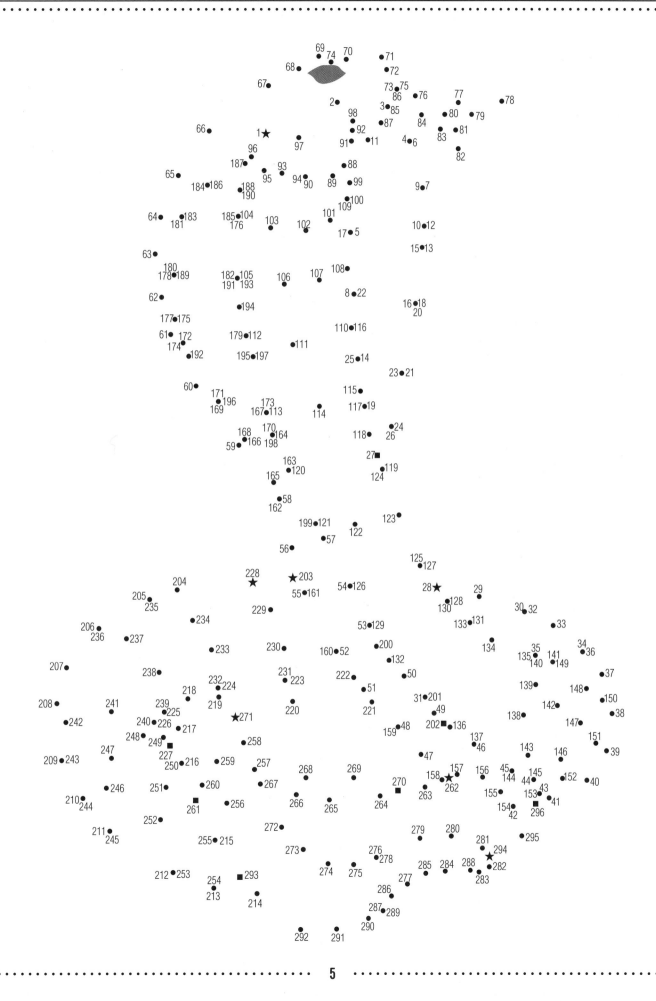

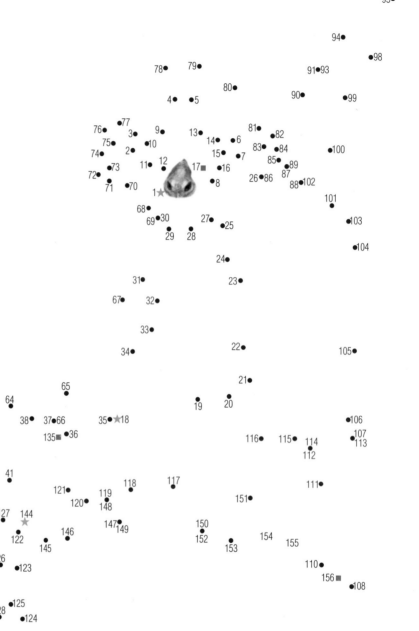

14

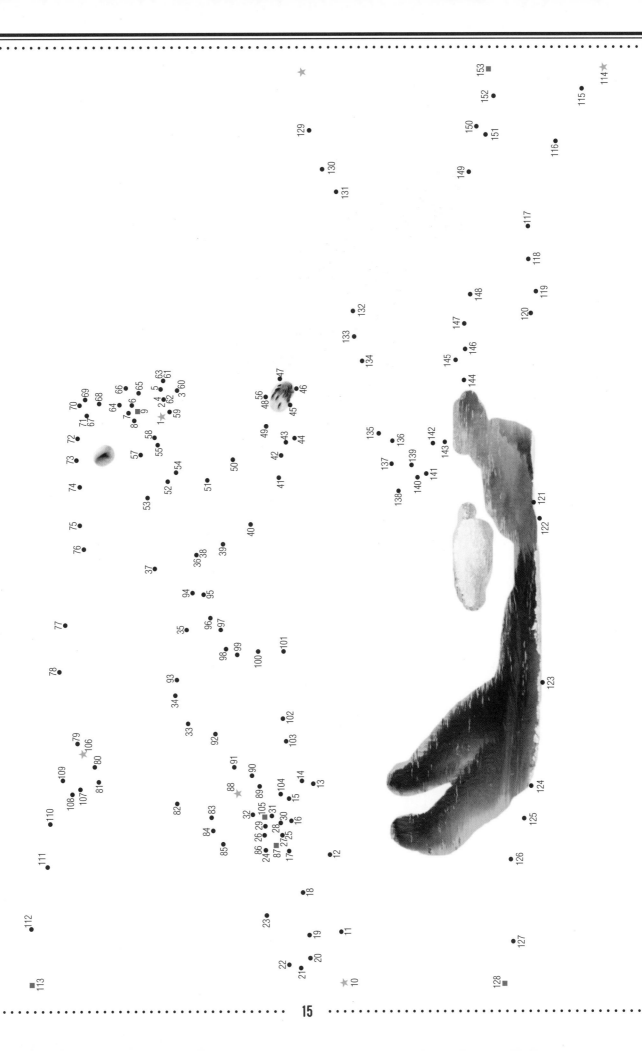

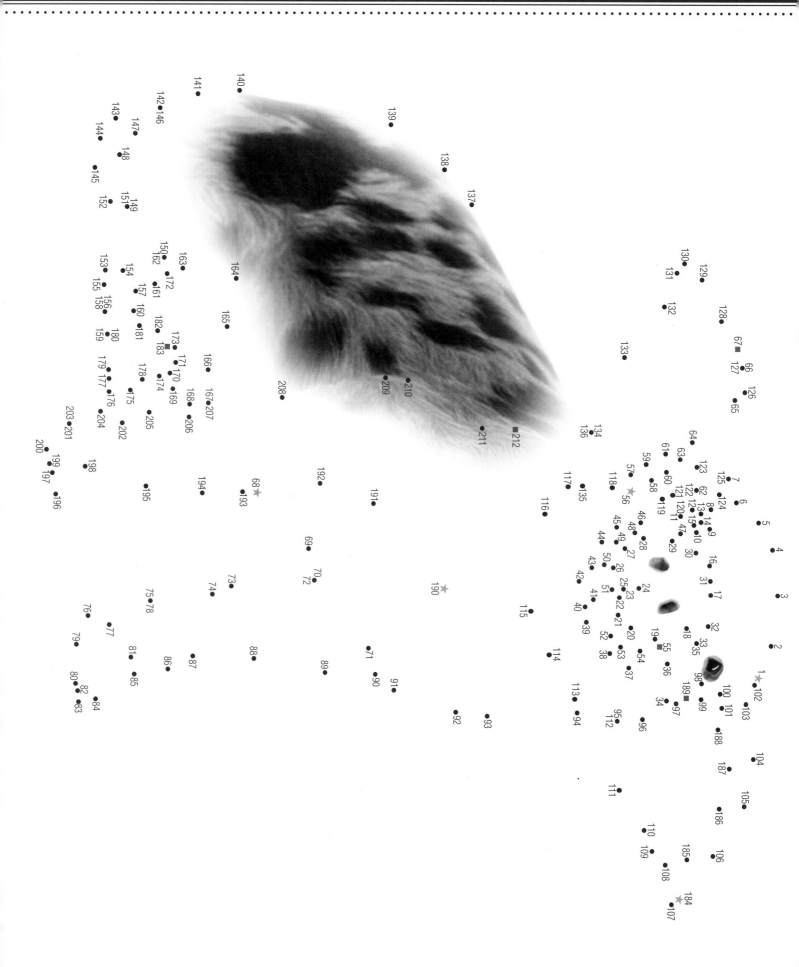

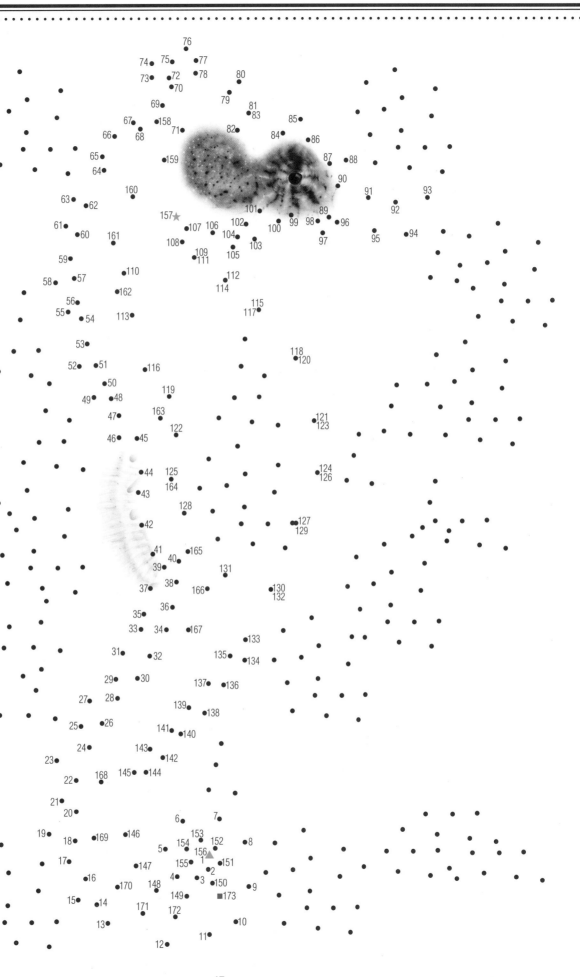

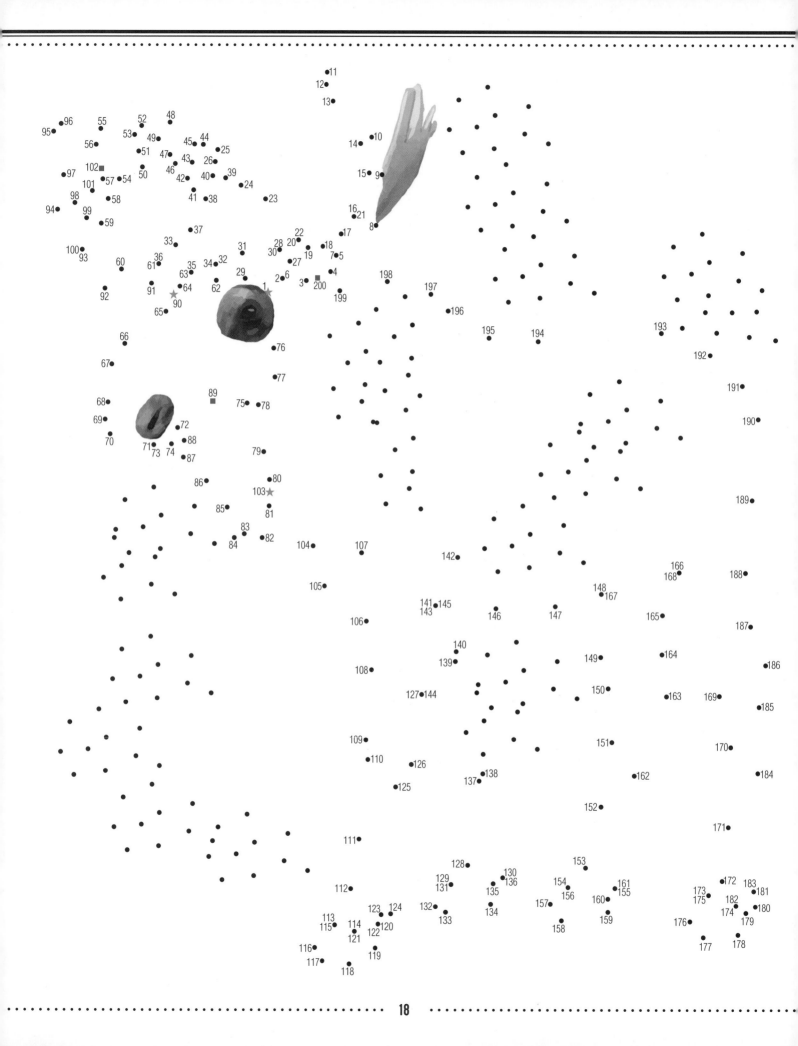

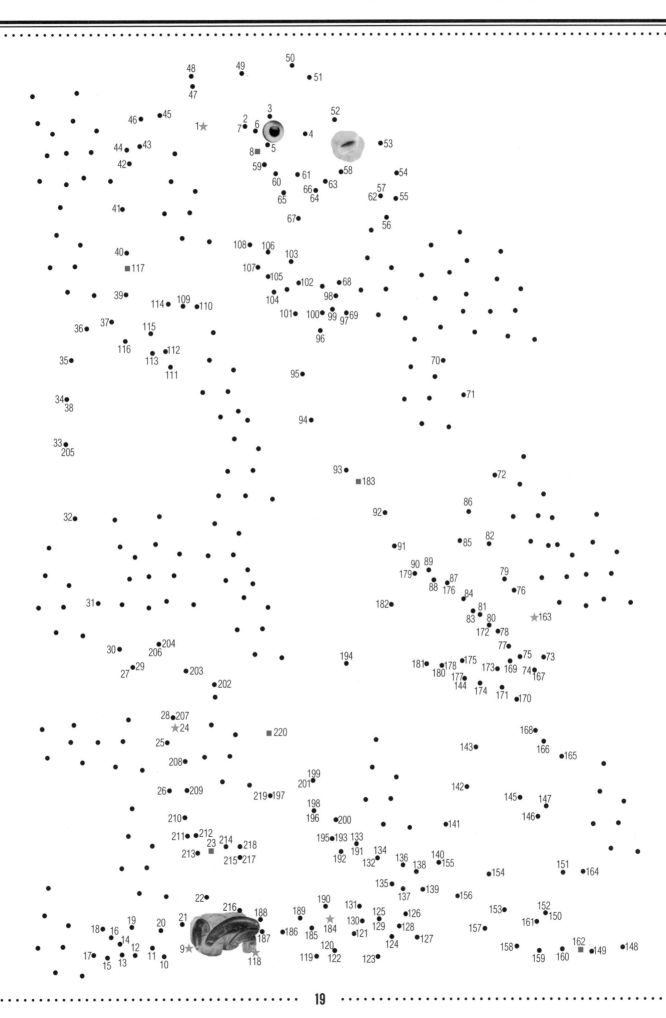

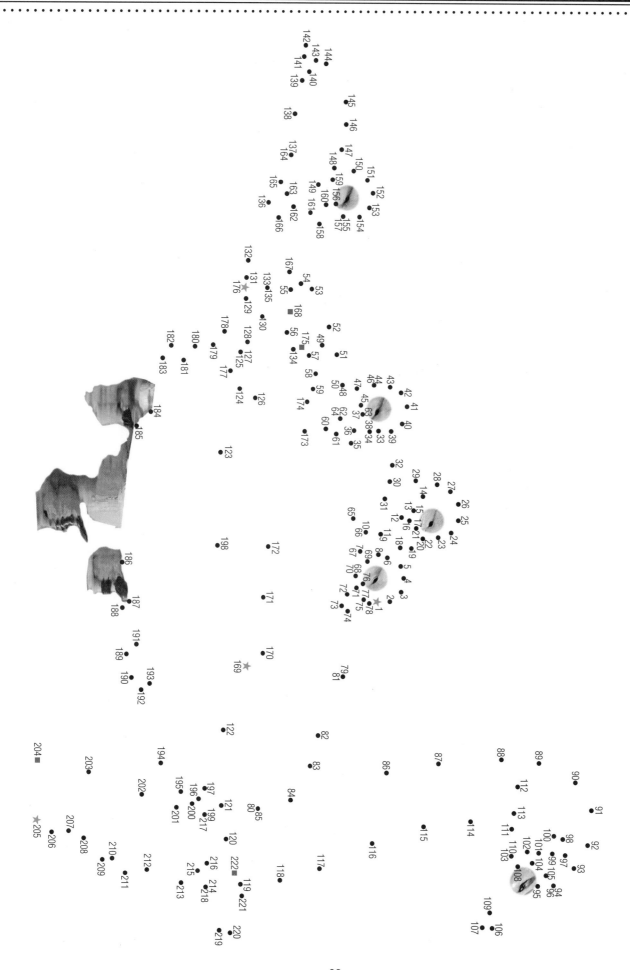

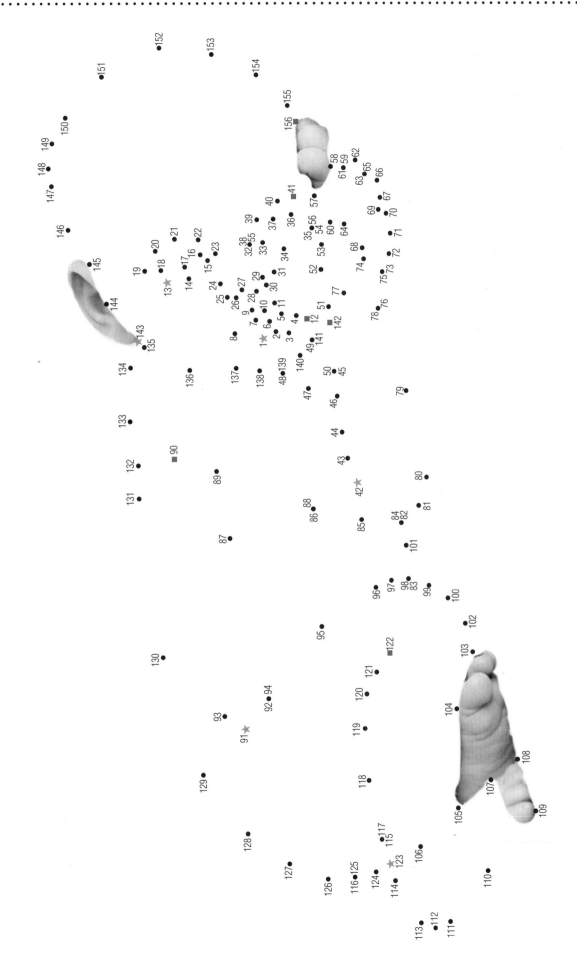

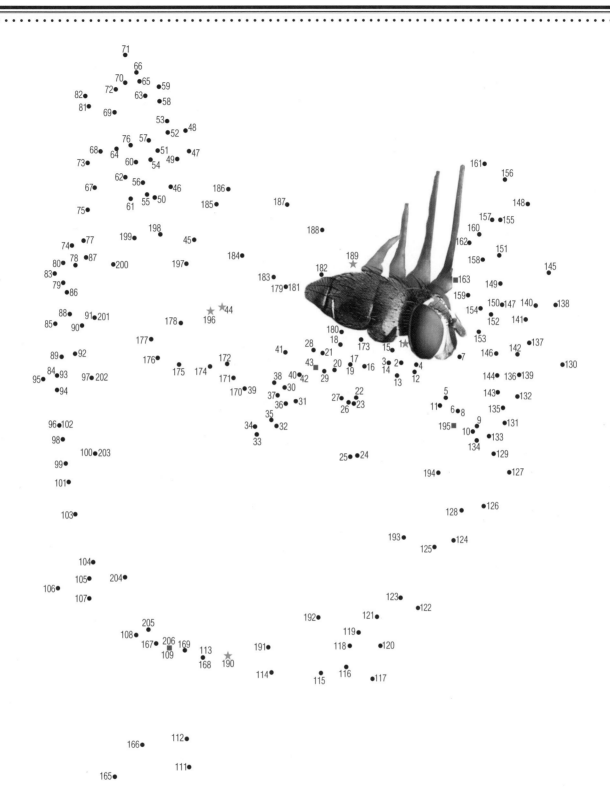

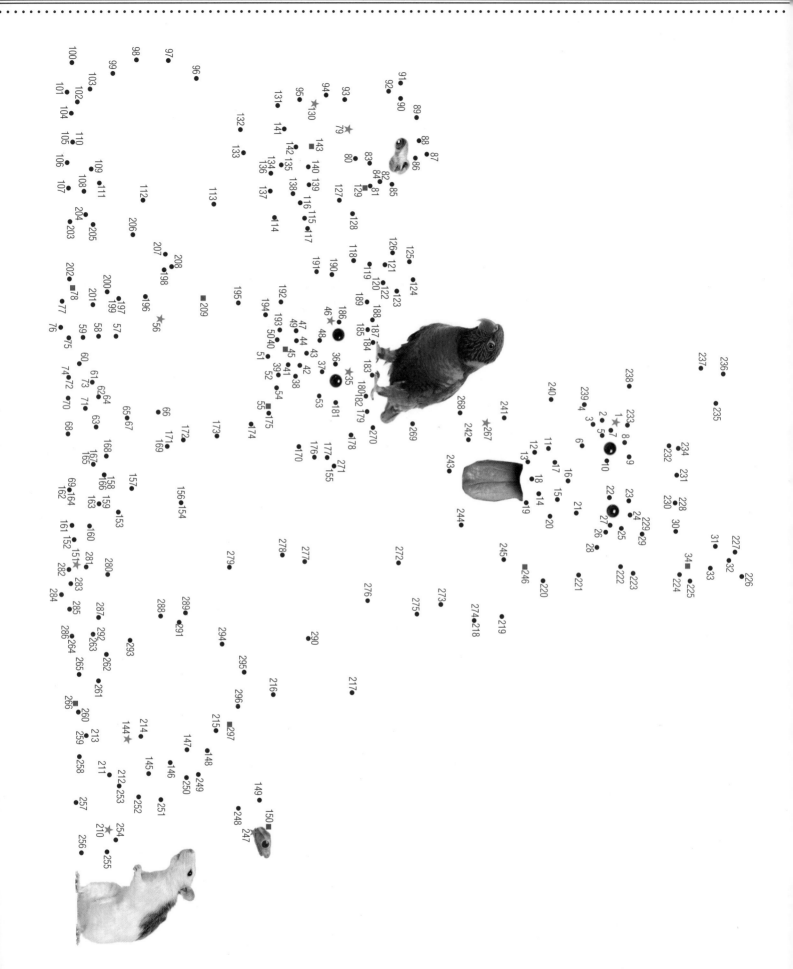

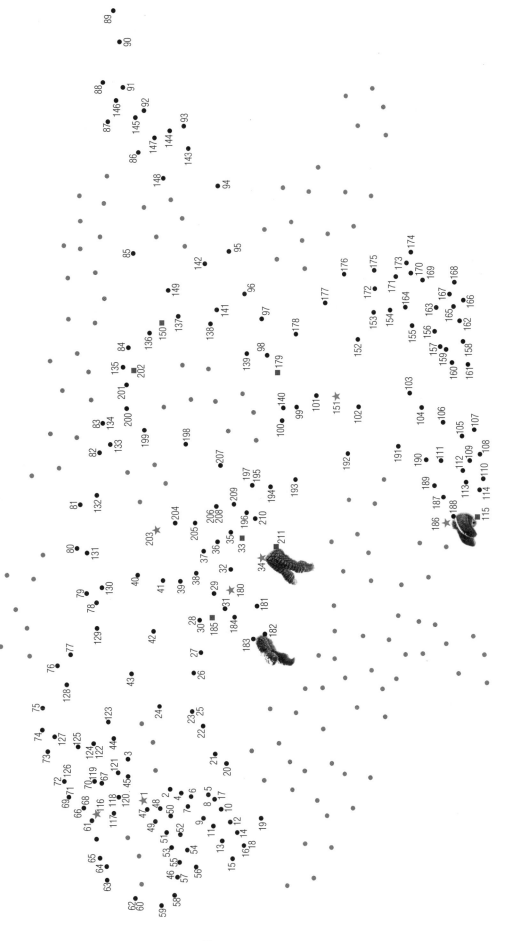

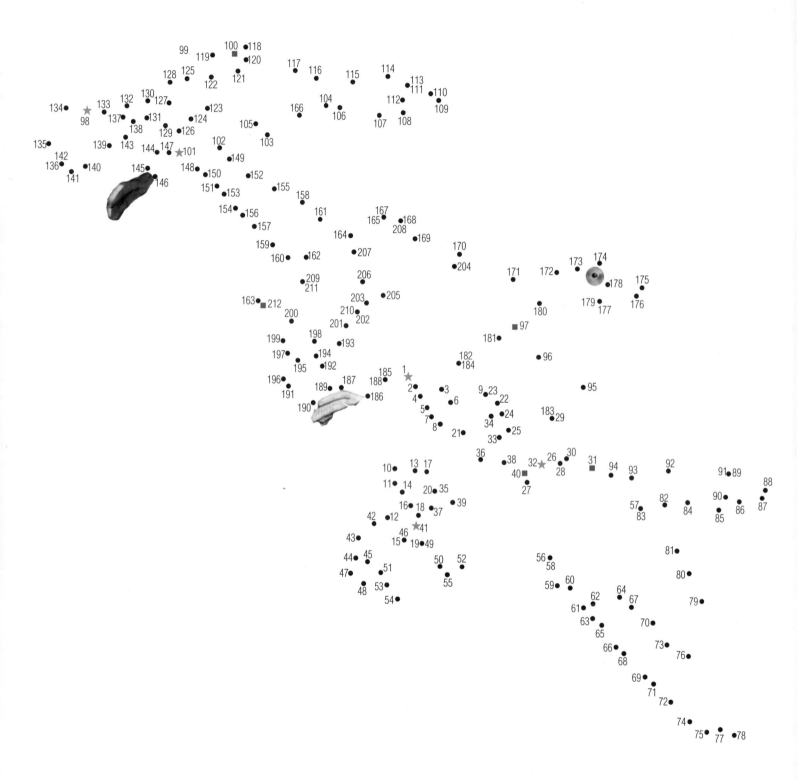

49

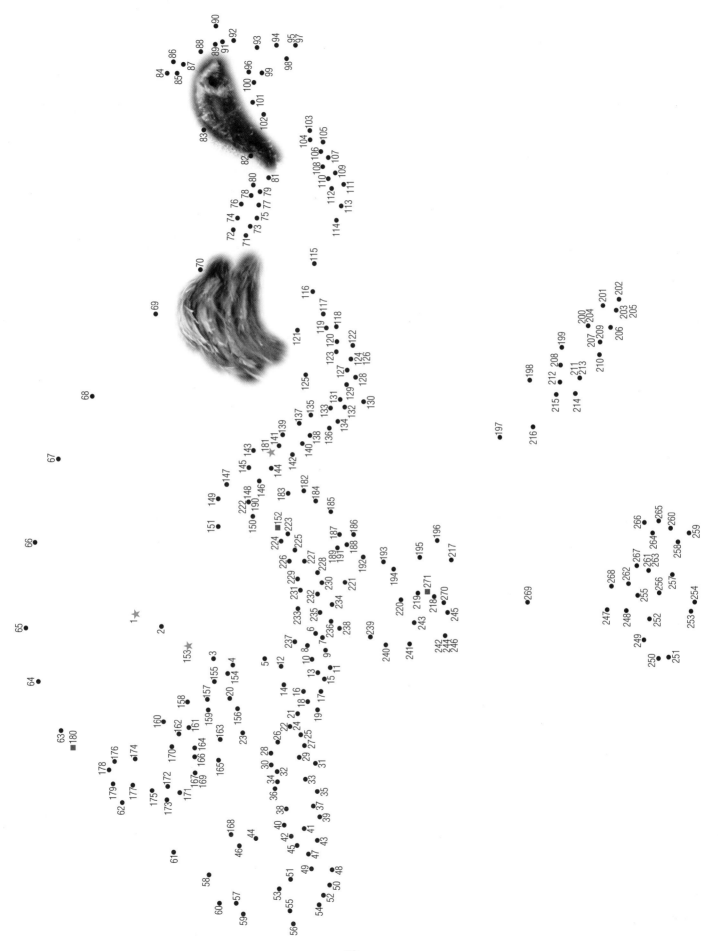

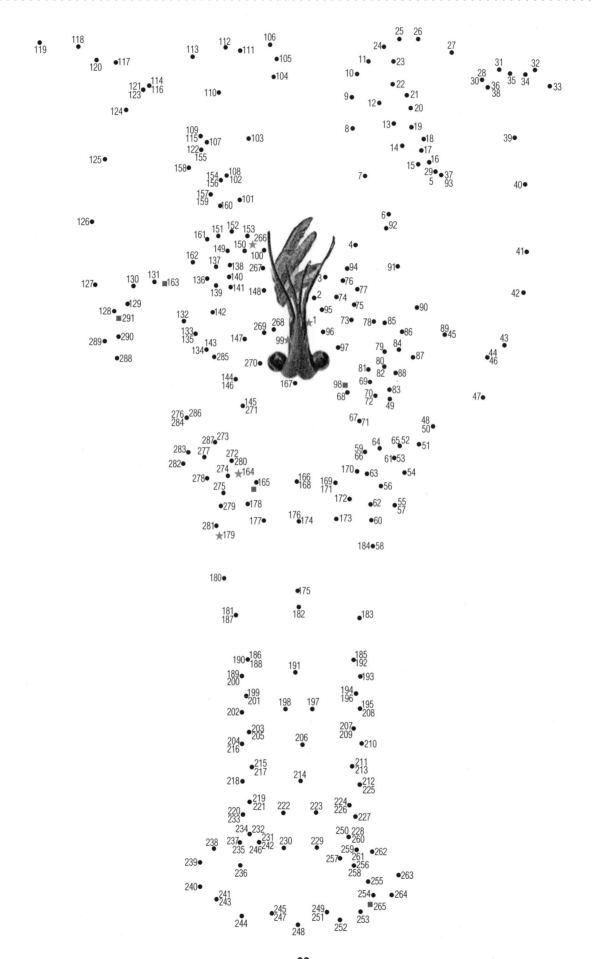

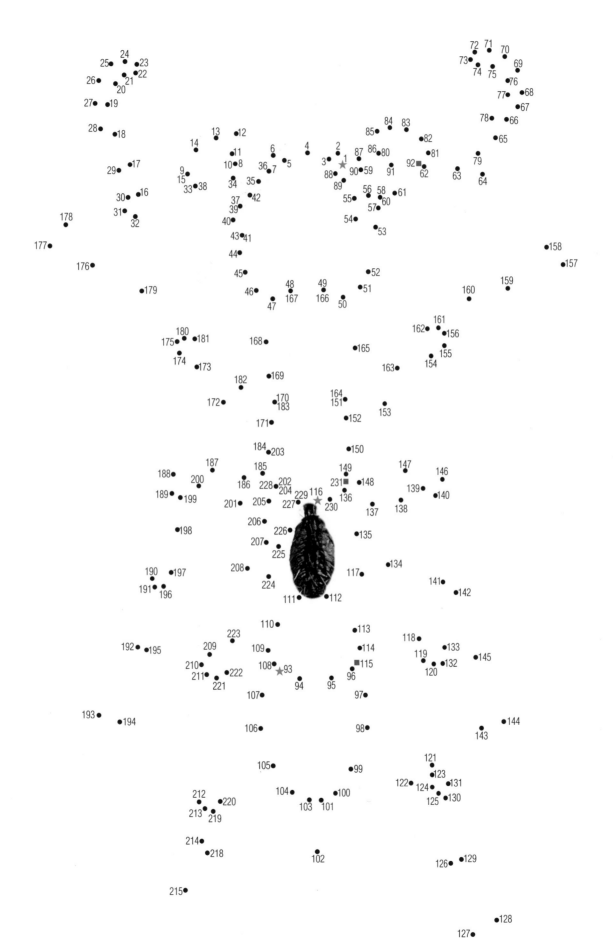

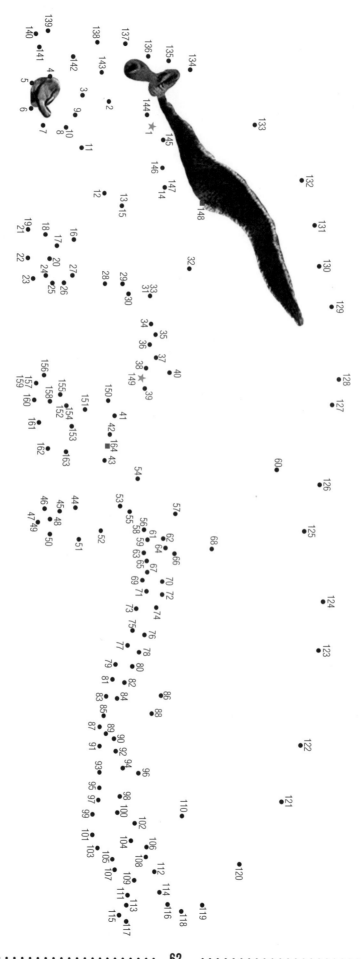

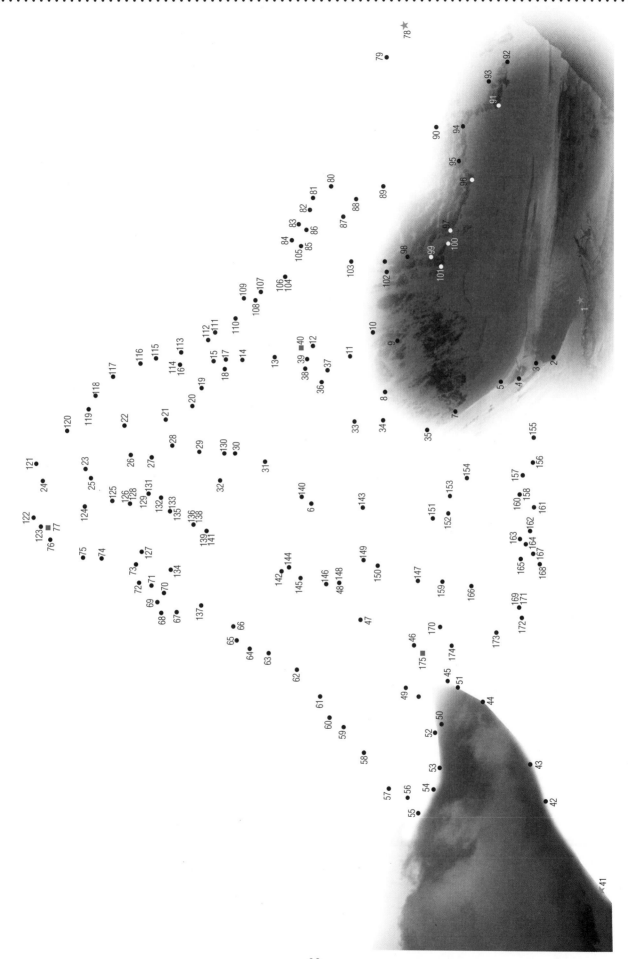

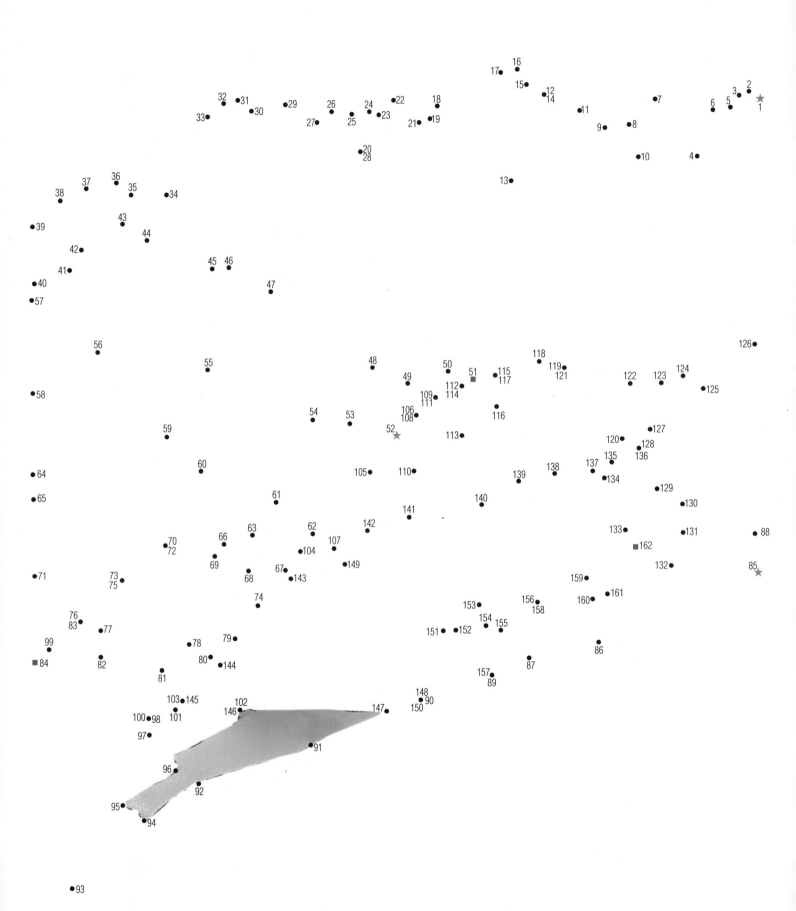

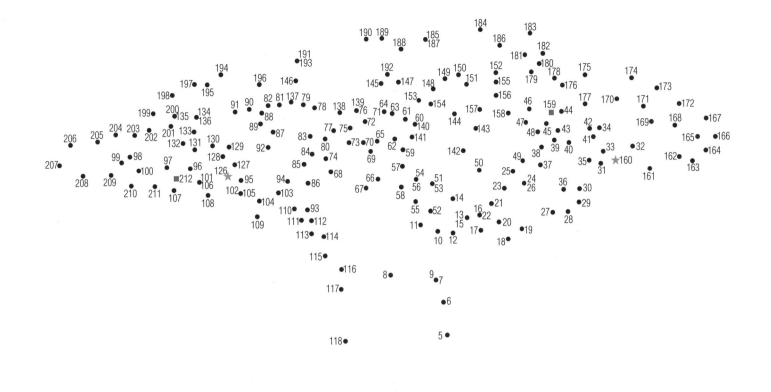

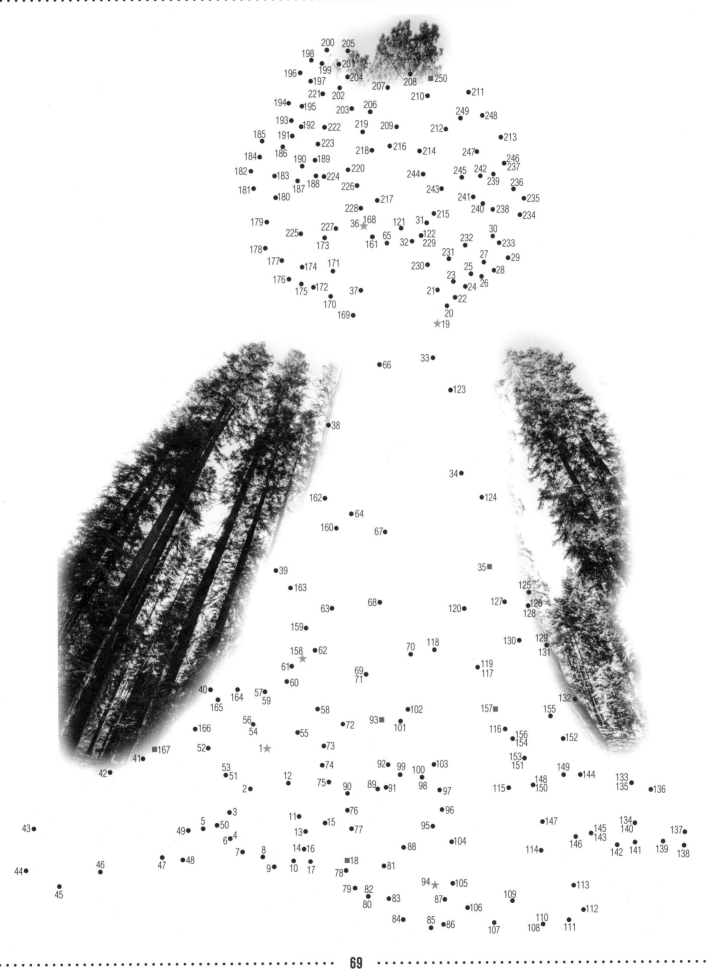

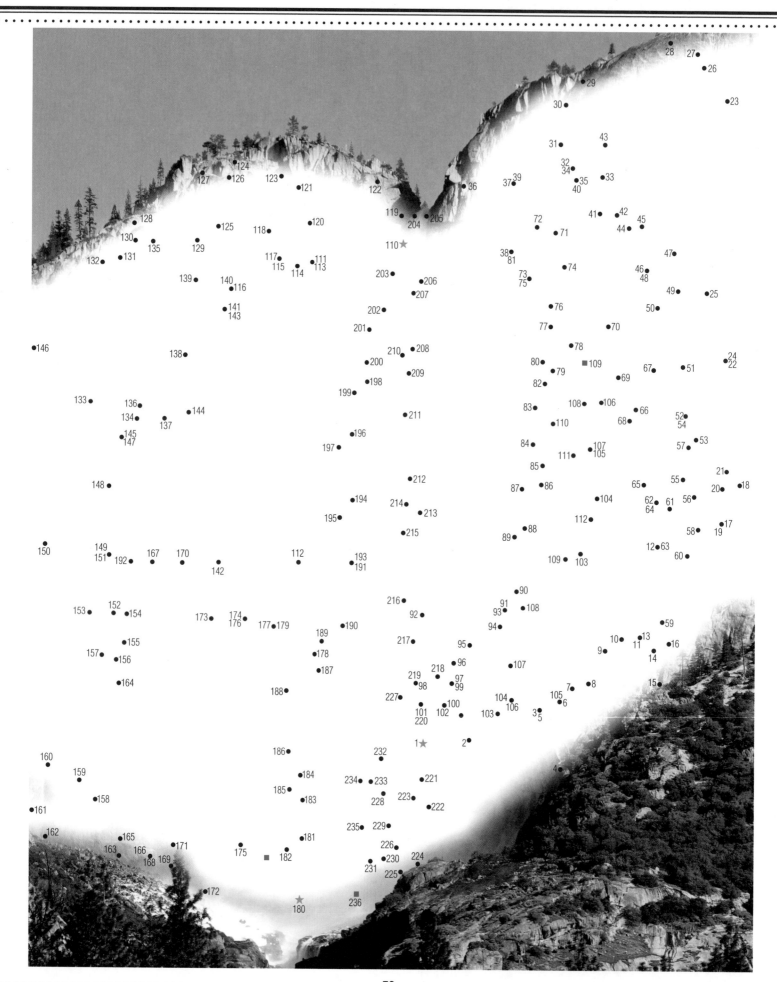

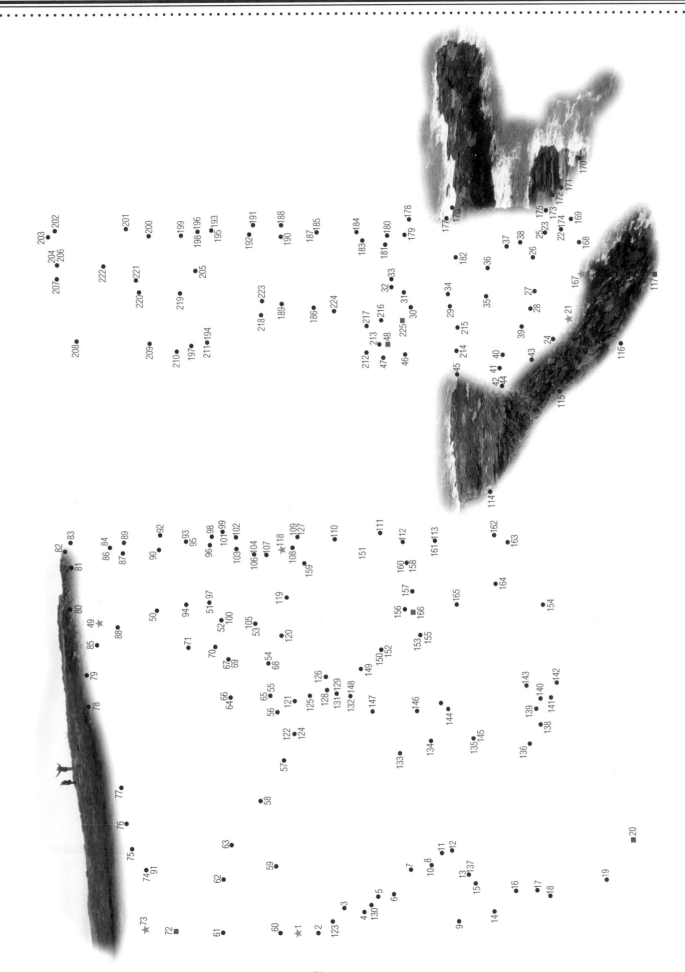

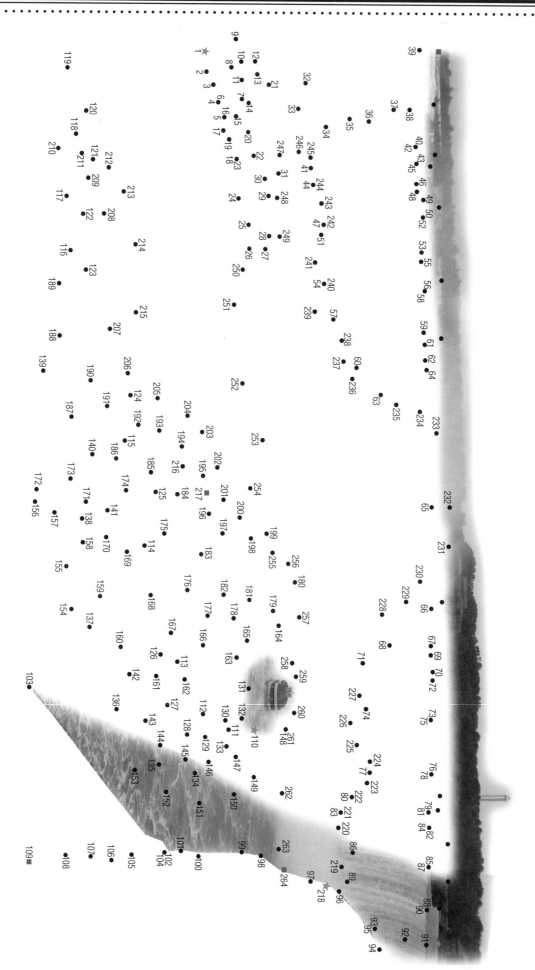

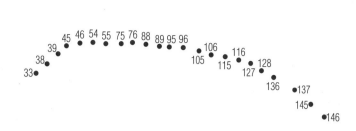

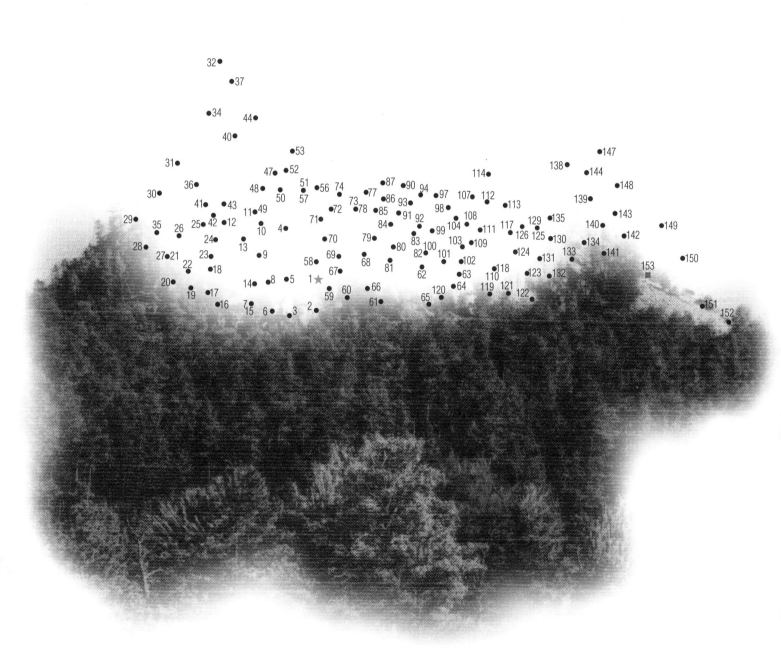

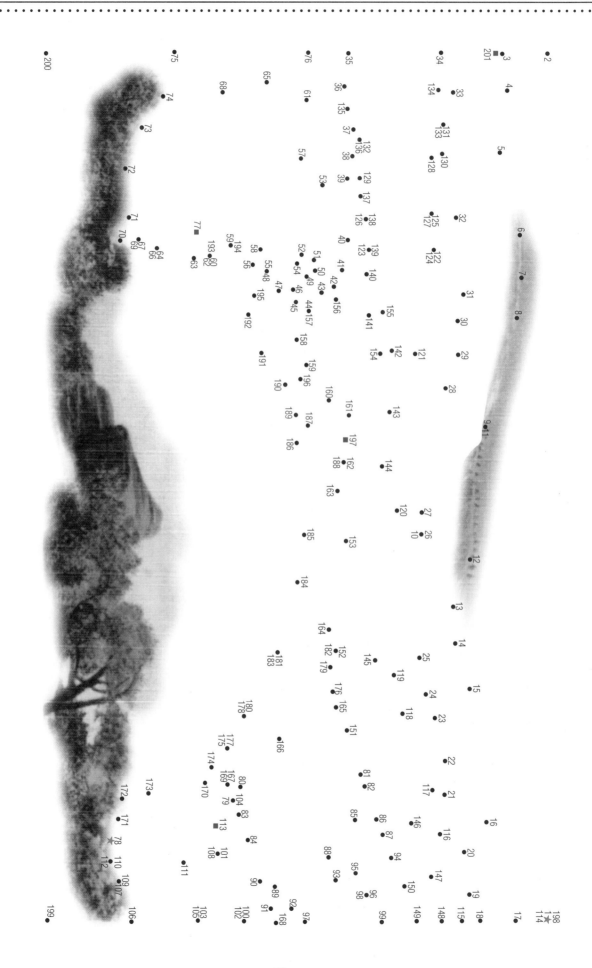

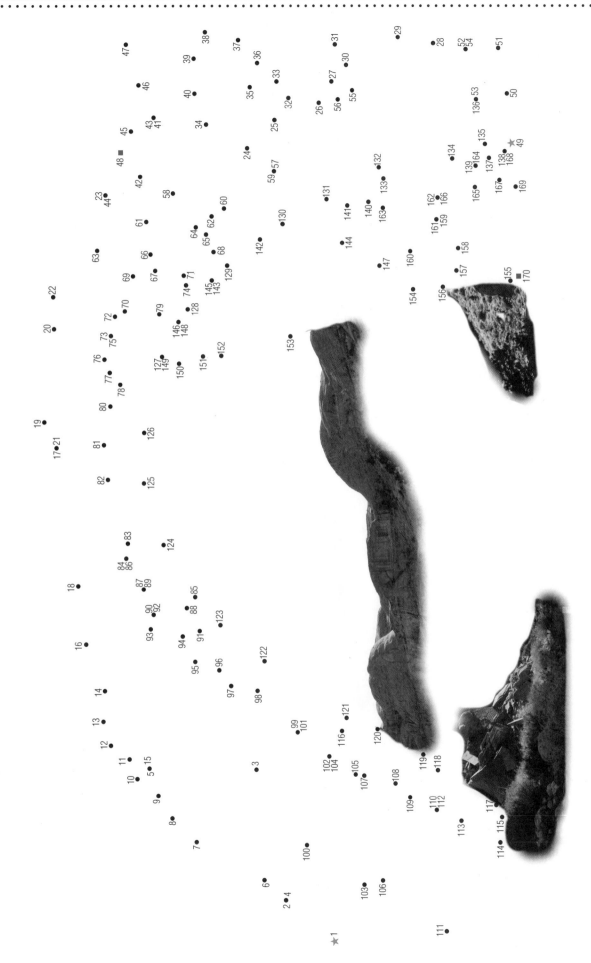

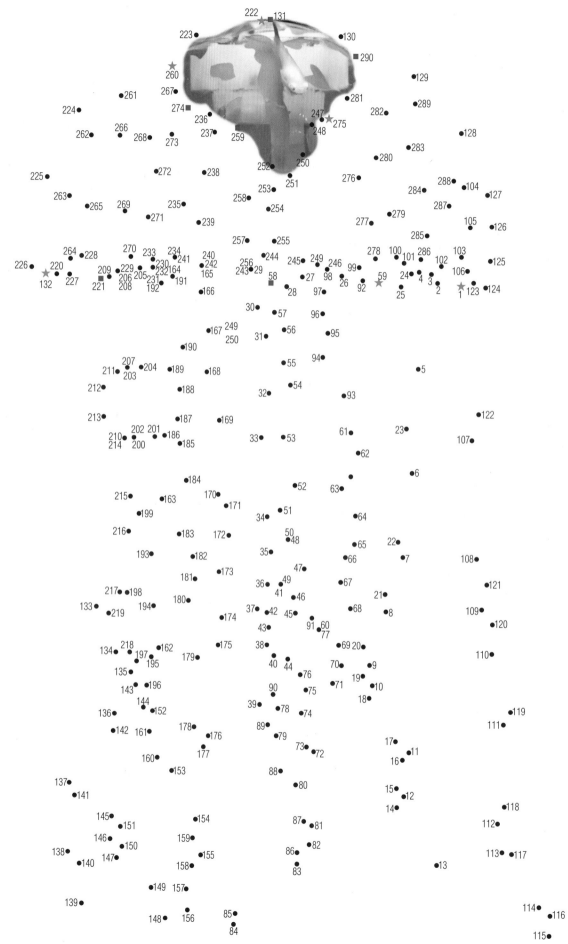

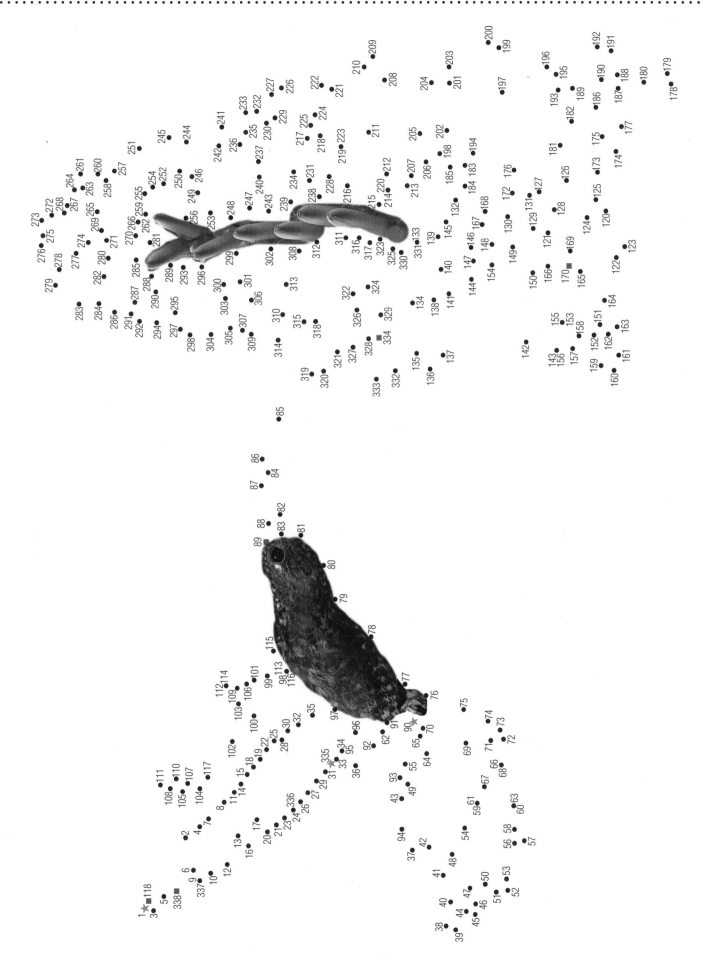

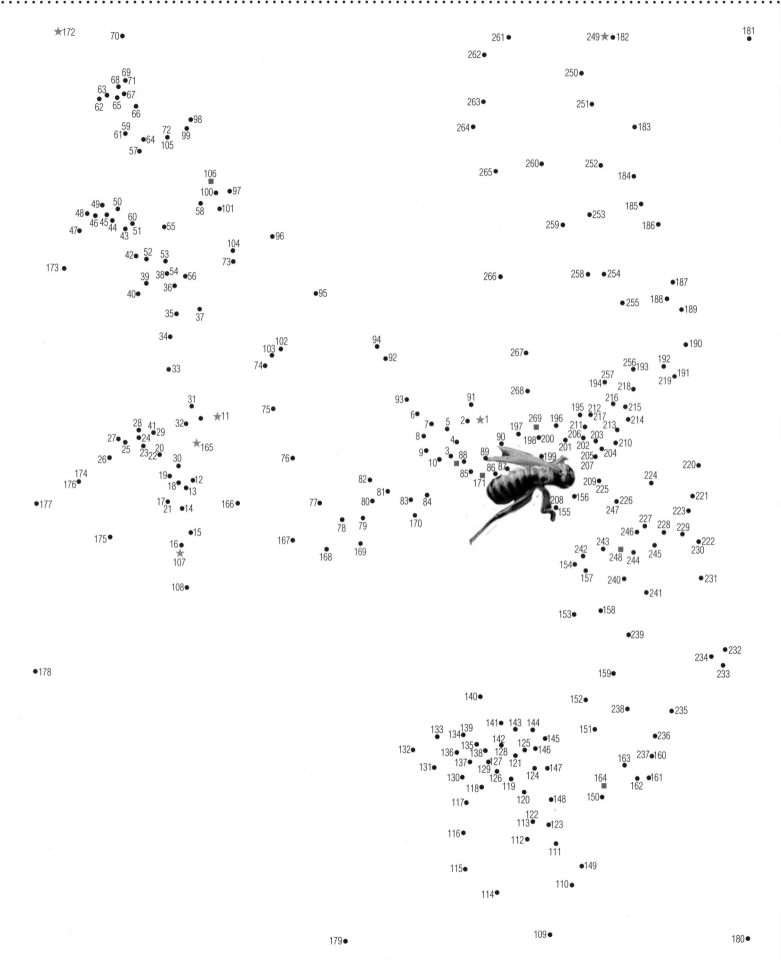

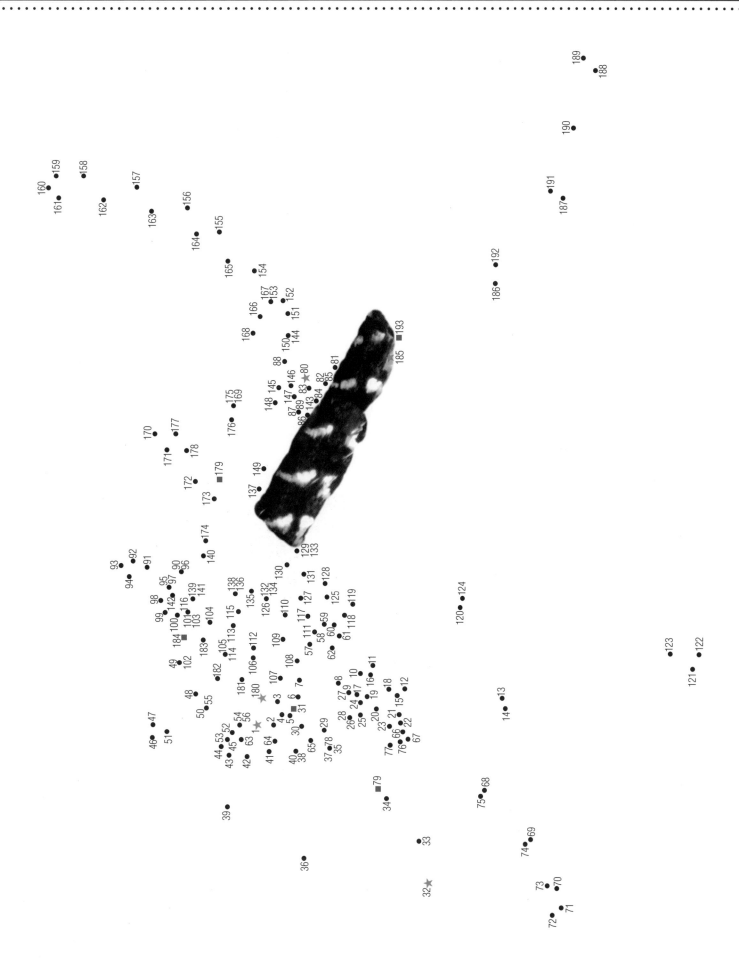

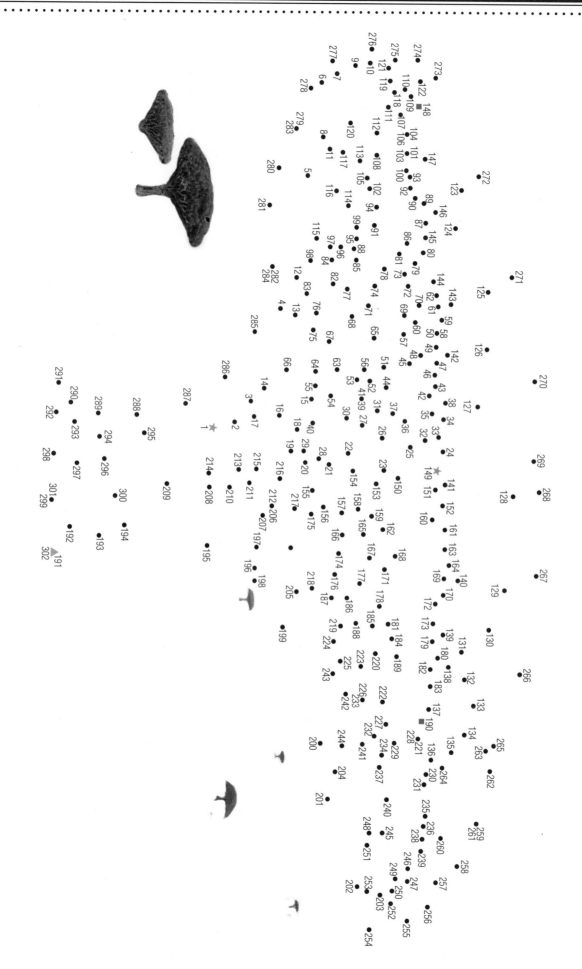

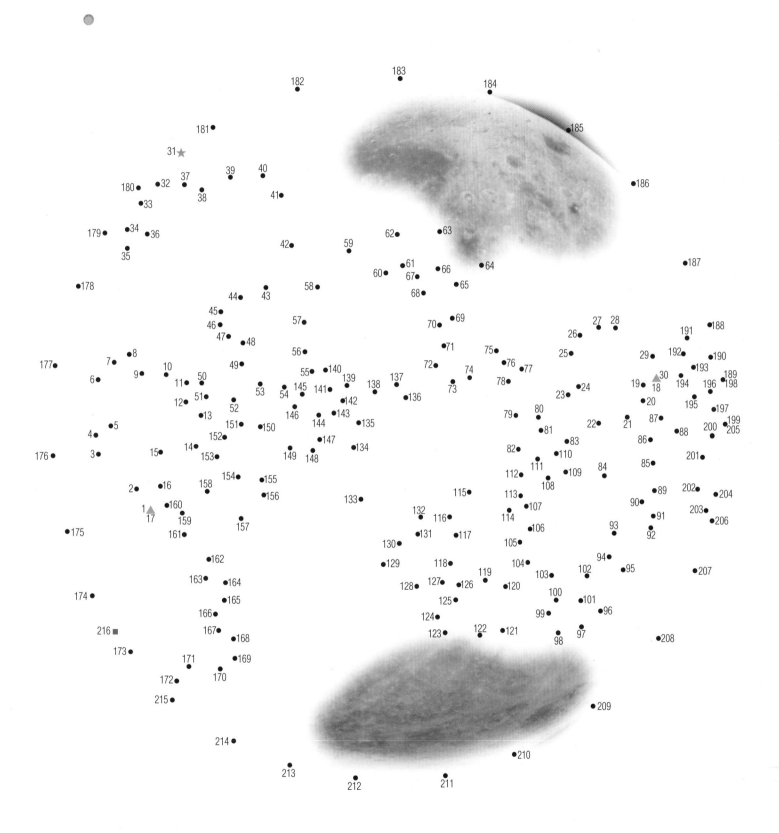

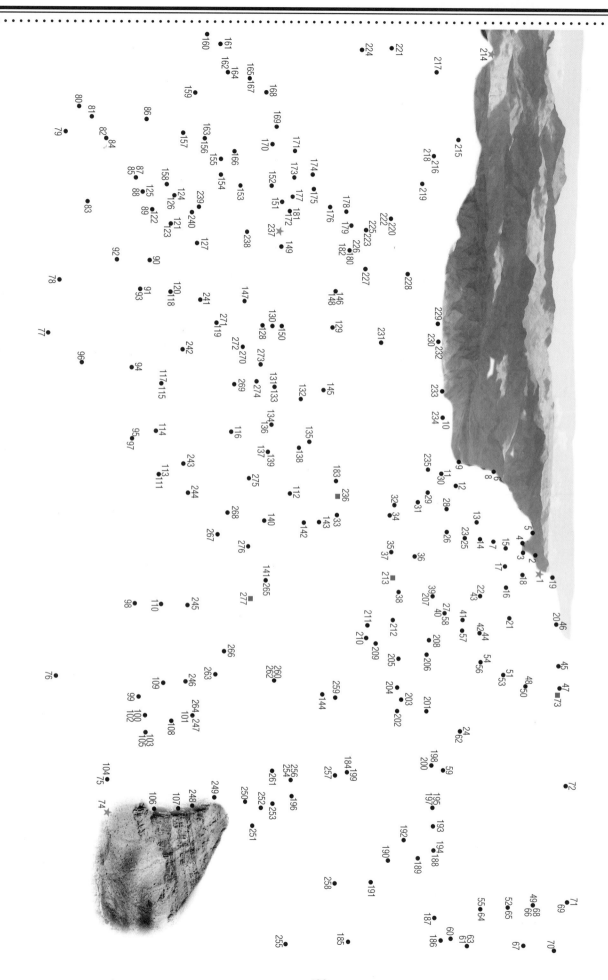

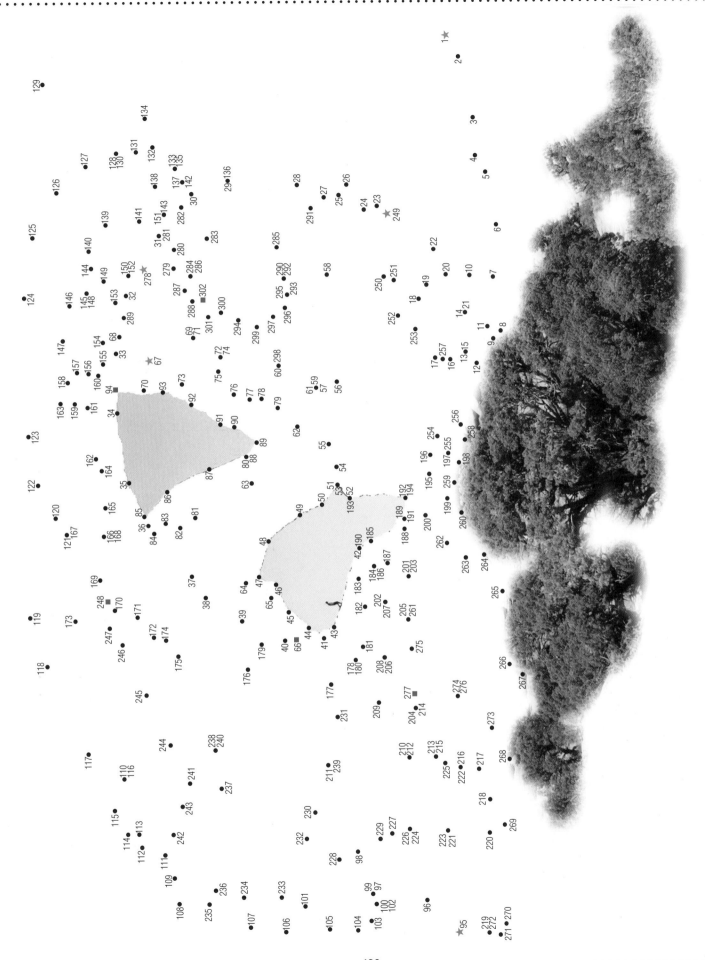

CHALLENGING ANSWERS

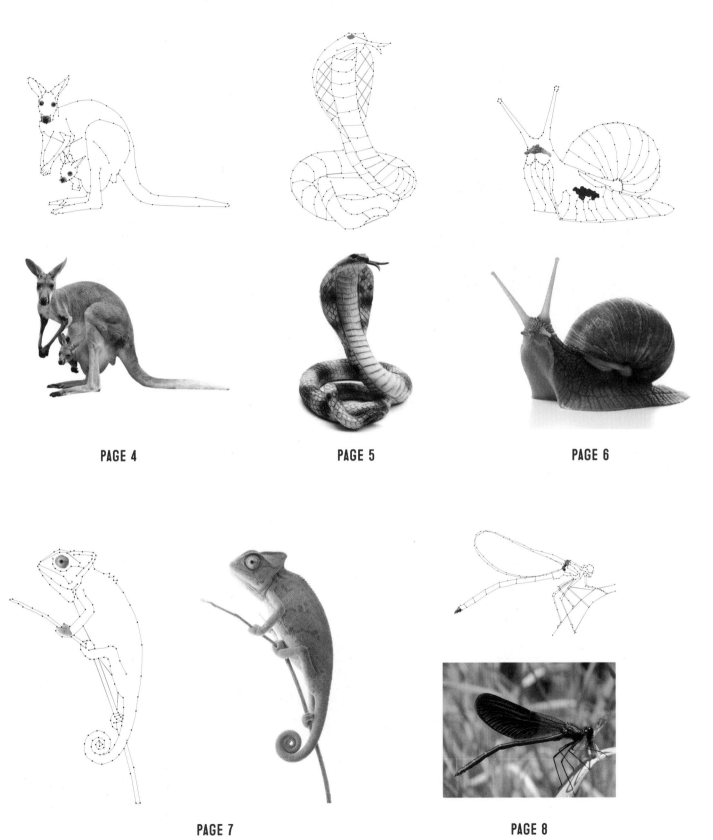

PAGE 4

PAGE 5

PAGE 6

PAGE 7

PAGE 8

CHALLENGING ANSWERS

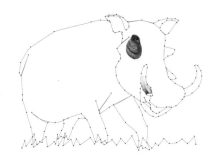

PAGE 9

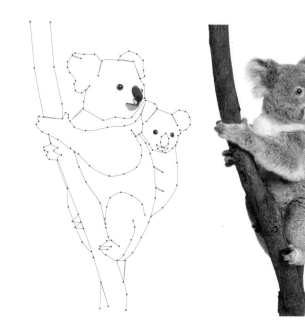

PAGE 10

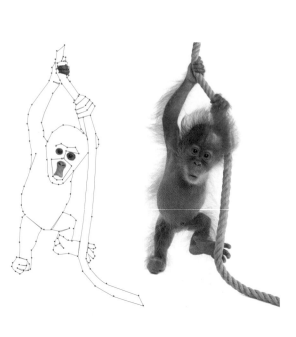

PAGE 11

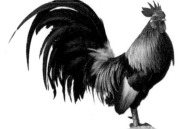

PAGE 12

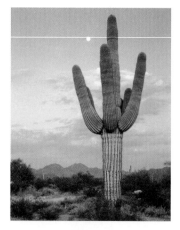

PAGE 13

CHALLENGING ANSWERS

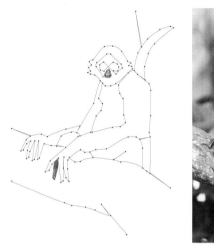

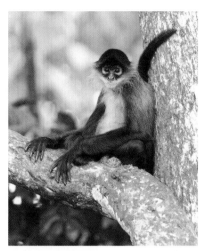

PAGE 14

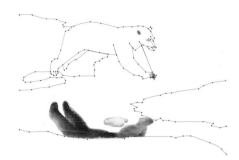

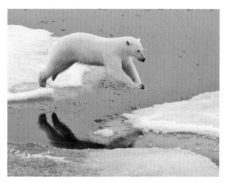

PAGE 15

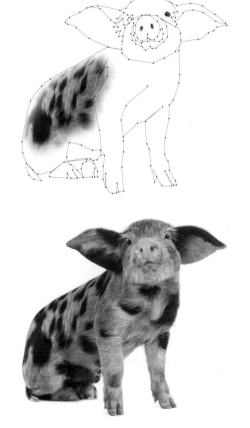

PAGE 16

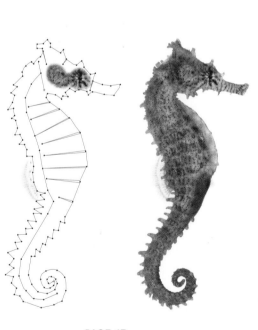

PAGE 17

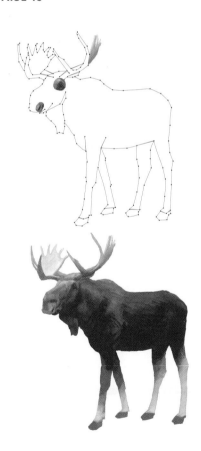

PAGE 18

CHALLENGING ANSWERS

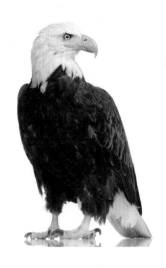

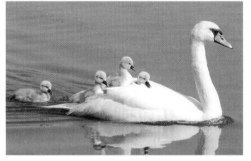

PAGE 19

PAGE 20

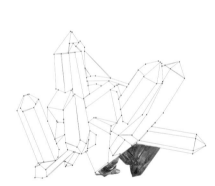

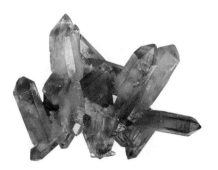

PAGE 21

PAGE 22

PAGE 23

CHALLENGING ANSWERS

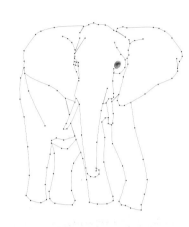

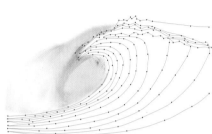

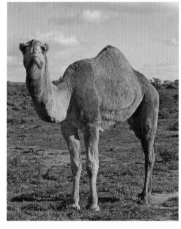

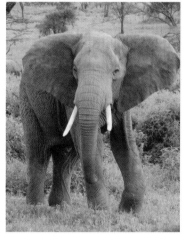

PAGE 24

PAGE 25

PAGE 26

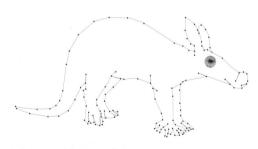

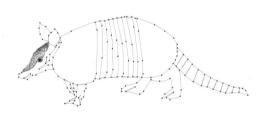

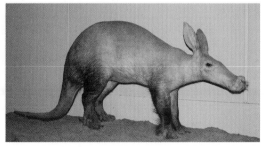

PAGE 27

PAGE 28

CHALLENGING ANSWERS

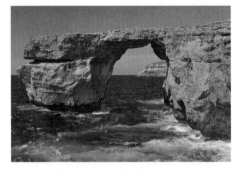

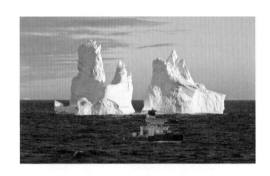

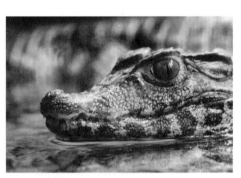

PAGE 29

PAGE 30

PAGE 31

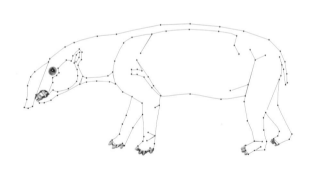

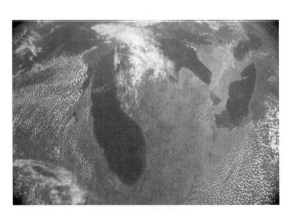

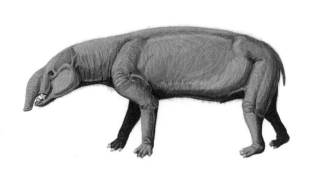

PAGE 32

PAGE 33

CHALLENGING ANSWERS

 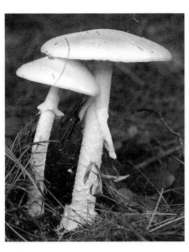

PAGE 34

 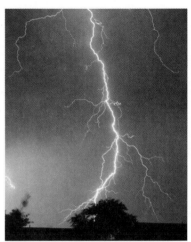

PAGE 35

 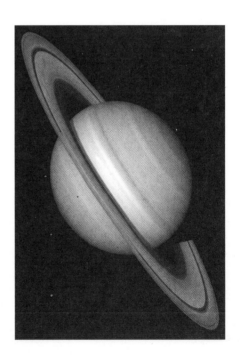

PAGE 36

REALLY CHALLENGING ANSWERS

PAGE 37

PAGE 38

PAGE 39

PAGE 40

PAGE 41

PAGE 42

REALLY CHALLENGING ANSWERS

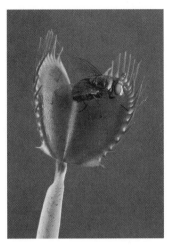

PAGE 43

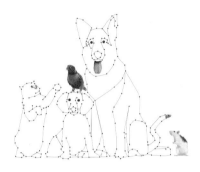
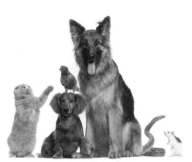

PAGE 44

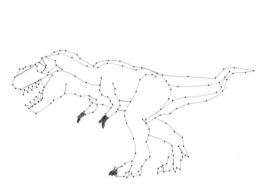

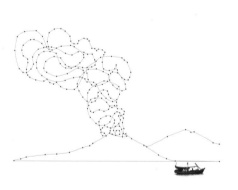

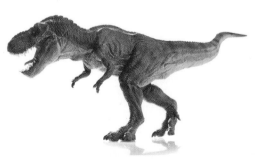

PAGE 45

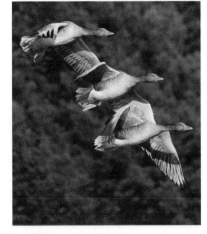
PAGE 46

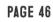
PAGE 47

REALLY CHALLENGING ANSWERS

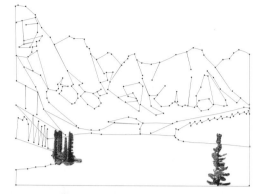

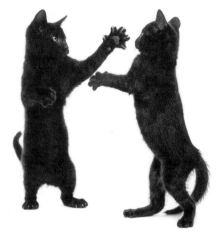

PAGE 49

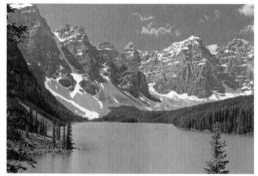

PAGE 48

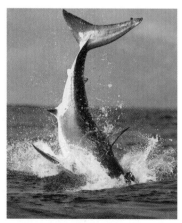

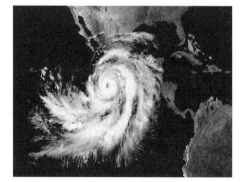

PAGE 51

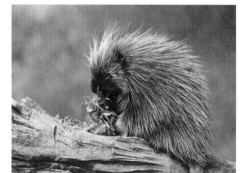

PAGE 52

PAGE 50

REALLY CHALLENGING ANSWERS

PAGE 53

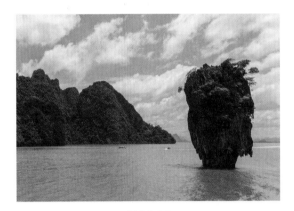

PAGE 54

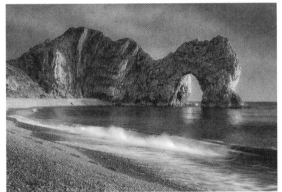

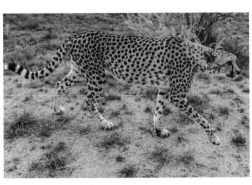

PAGE 55

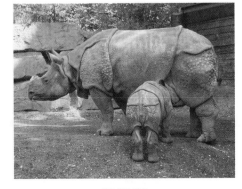

PAGE 56

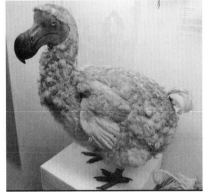

PAGE 57

REALLY CHALLENGING ANSWERS

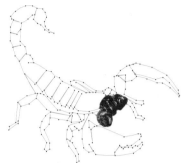

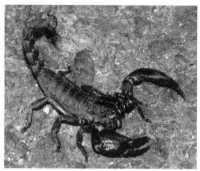

PAGE 58

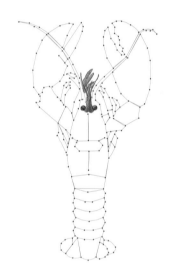

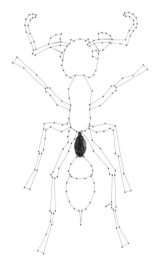

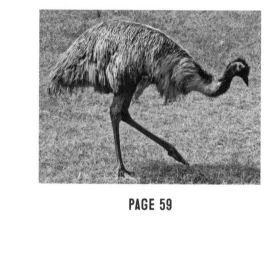

PAGE 59

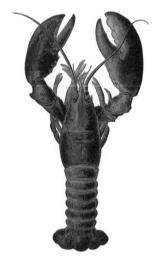

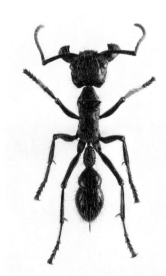

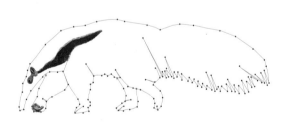

PAGE 60

PAGE 61

PAGE 62

REALLY CHALLENGING ANSWERS

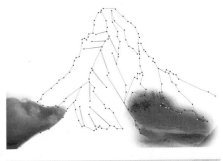

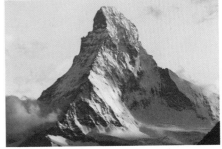

PAGE 63

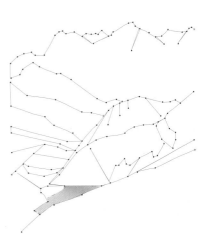

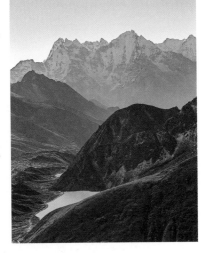

PAGE 64

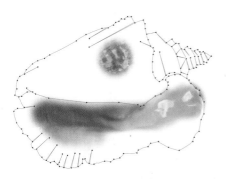

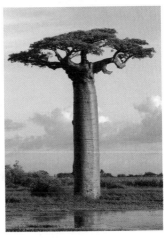

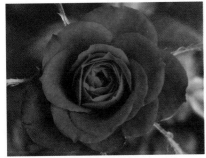

PAGE 65

PAGE 66

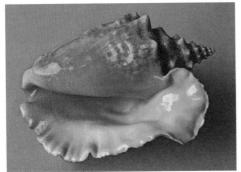

PAGE 67

REALLY CHALLENGING ANSWERS

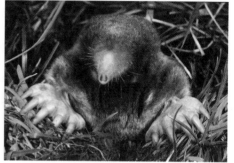

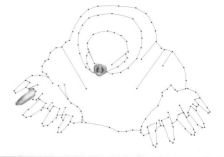

PAGE 68

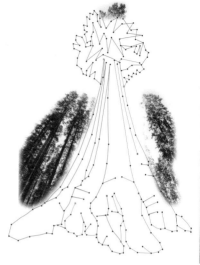

PAGE 69

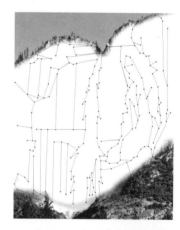

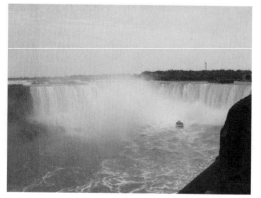

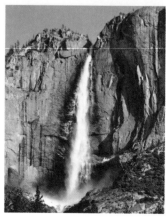

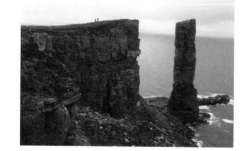

PAGE 70

PAGE 71

PAGE 72

REALLY CHALLENGING ANSWERS

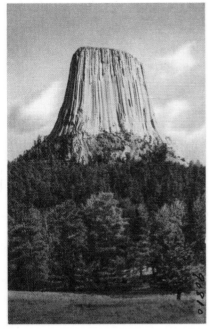

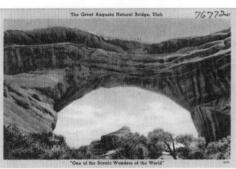

PAGE 73

PAGE 74

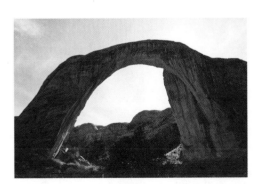

PAGE 75

PAGE 76

SUPER-DUPER CHALLENGING ANSWERS

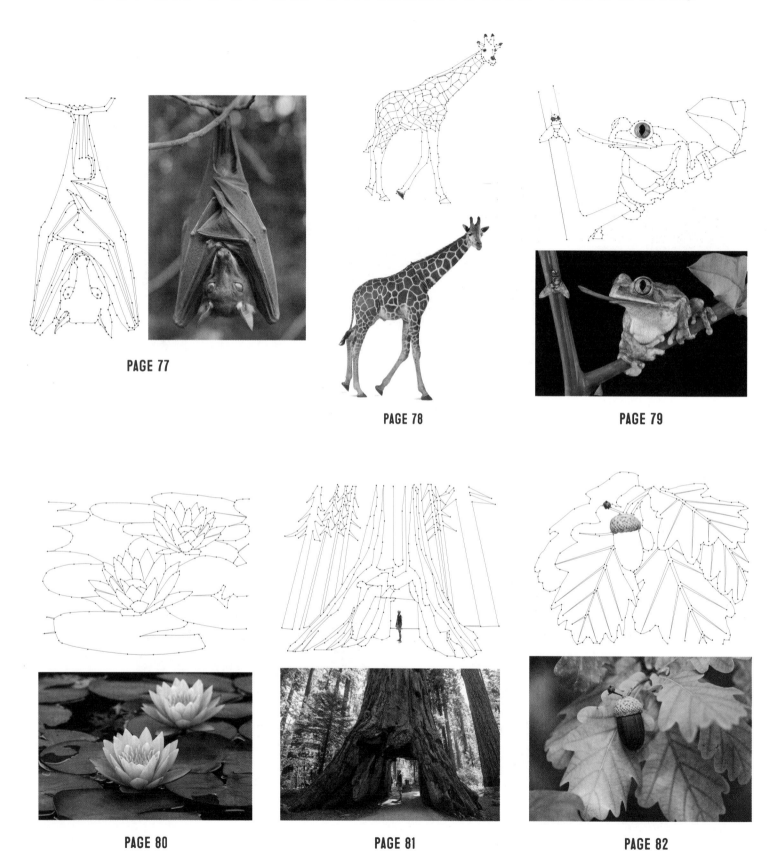

PAGE 77

PAGE 78

PAGE 79

PAGE 80

PAGE 81

PAGE 82

SUPER-DUPER CHALLENGING ANSWERS

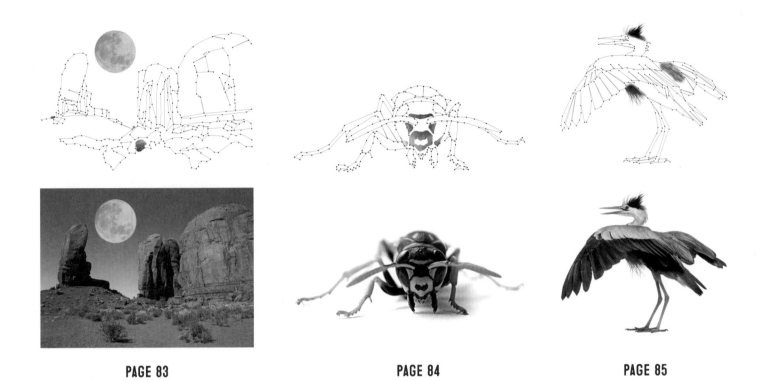

PAGE 83

PAGE 84

PAGE 85

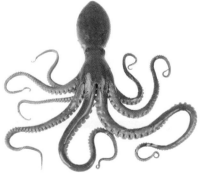

PAGE 86

PAGE 87

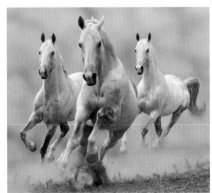

SUPER-DUPER CHALLENGING ANSWERS

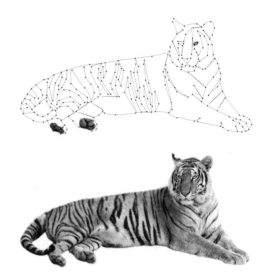

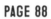

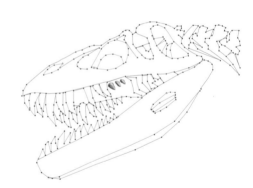

PAGE 88

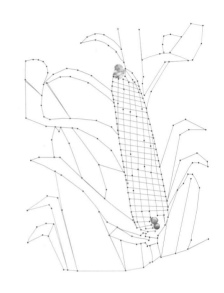

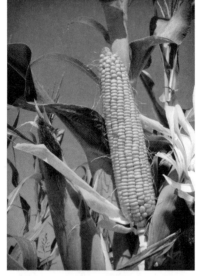

PAGE 89

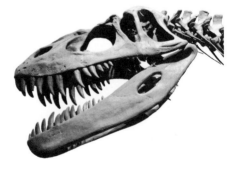

PAGE 90

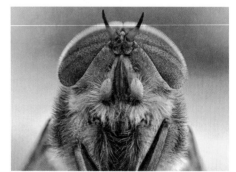

PAGE 91

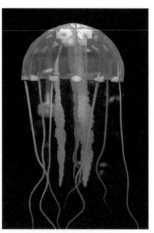

PAGE 92

SUPER-DUPER CHALLENGING ANSWERS

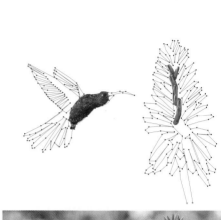

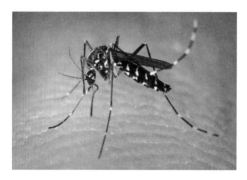

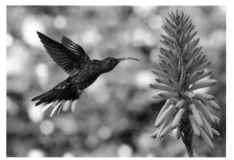

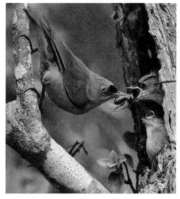

PAGE 93

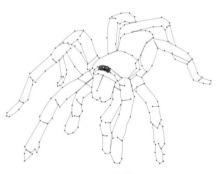

PAGE 94

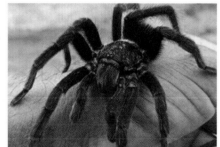

PAGE 95

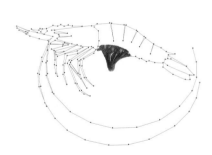

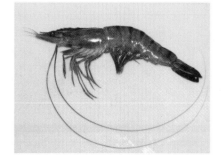

PAGE 96

PAGE 97

SUPER-DUPER CHALLENGING ANSWERS

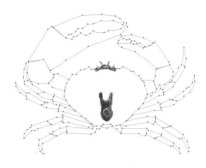

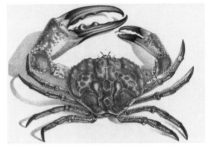

PAGE 98

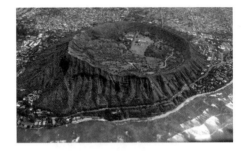

PAGE 99

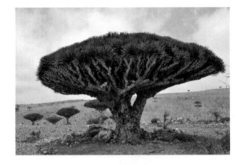

PAGE 100

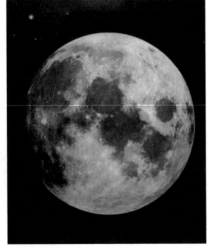

PAGE 101

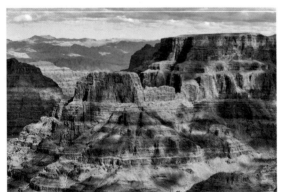

PAGE 102

SUPER-DUPER CHALLENGING ANSWERS

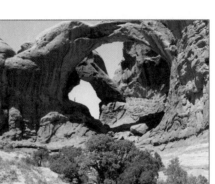

PAGE 103

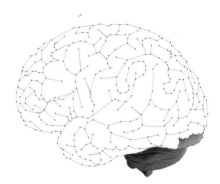
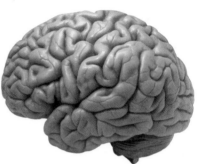

PAGE 104

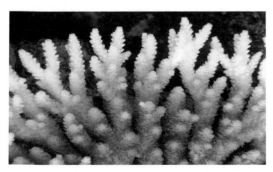

PAGE 105

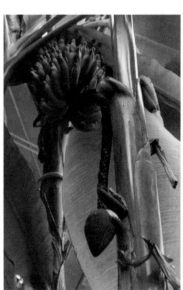

PAGE 106

PHOTO ACKNOWLEDGMENTS

Images from Shutterstock.com

3523studio (front cover-right and pages 82 and 122-bottom right), Artshock (pages 101 and 126-bottom left), Baimieng (pages 41 and 114-bottom center), Heidi Brand (pages 21 and 110 bottom-left), Linda Bucklin (pages 40 and 114-bottom left), David Herraez Calzada (pages 90 and 124-bottom left), Karel Gallas (pages 20 and 110-top right), Harvepino (pages 51 and 116-bottom center), Bernadette Heath (pages 13 and 108-bottom right), Justin Hobson (pages 38 and 114-top middle), Eric Isselee (front cover-left and pages 10, 11, 16, 17, 19, 37, 42, 44, 49, 78, 85, 108-top right, 108-bottom left, 109-bottom left, 109-bottom middle, 110-top left, 114-top left, 114-bottom right, 115-top right, 116-top right, 122-top center, and 123-top right), Jbpics (pages 53 and 117-top left), Anan Kaewkhammul (pages 4 and 107-top left), Kamonrat (pages 88 and 124-top left), Karamysh (pages 48 and 116-top left), Cathy Keifer (back cover and pages 43, 79, 115-top left, and 122-top right), Ivan Kuzmin (pages 77 and 122-top left), Leisuretime70 (pages 80 and 122-bottom left), Felix Lipov (pages 69 and 120-top right), Longjourneys (pages 24 and 111-top left), Mariait (pages 87 and 123-bottom right), Mbolina (pages 93 and 125-top left), Vladimir Melnik (pages 15 and 109-top right), Metha1819 (pages 45 and 115-bottom left), Jiri Miklo (pages 39 and 114-top right), Lipowski Milan (pages 7 and 107-bottom left), Byelikova Oksana (pages 47 and 115-bottom right), OljaS (pages 8 and 107-bottom right), Vadim Petrakov (pages 64 and 119-top right), Photosync (pages 5 and 107-top middle), Darren Pullman (pages 46 and 115-bottom middle), Zeljko Radojko (pages 89 and 124-top right), Tony Rix (pages 52 and 116-bottom right), Albert Russ (pages 23 and 110-bottom right), Michael Sheehan (pages 9 and 108-top left), Sam Spicer (pages 81 and 122-bottom middle), Stockfoto (pages 84 and 123-top middle), Super Prin (pages 94 and 125-top middle), Tobkatrina (pages 83 and 123-top left), Tratong (pages 12 and 108-bottom middle), Sergey Uryadnikov (pages 50 and 116-bottom left), Vnlit (pages 6 and 107-top right), Ireneusz Waledzik (pages 91 and 124-bottom middle), Worlds Wildlife Wonders (pages 14, 22, 109-top left, and 110-bottom middle), Zhengzaishuru (pages 86, 92, 123-bottom left, and 124-bottom right), and Ilya Zonov (pages 18 and 109-bottom right)

Images from Other Sources

Tony Alter/Flickr/adapted (pages 76 and 121-bottom right), Dmitry Bogdanov/Wikimedia Commons/adapted (pages 33 and 112-bottom right), Kenneth Catania/Vanderbilt University (pages 68 and 120-top left), Centers for Disease Control and Prevention (pages 95 and 125-top right), Cheesy42/Wikimedia Commons/adapted (pages 67 and 119-bottom right), Chil/Wikimedia Commons/adapted (pages 63 and 119-top left), Jayendra Chiplunkar/Wikimedia Commons/adapted (pages 58 and 118-top left), Diego Delso/Wikimedia Commons/adapted (pages 54 and 117-top right), Didier Descouens/Wikimedia Commons/adapted (pages 61 and 118-bottom middle), Tim Felce/Flickr/adapted (pages 102 and 126-bottom right), Tom Friedel/Wikimedia Commons/adapted (pages 28 and 111-bottom right), Bernard Gagnon/Wikimedia Commons/adapted (pages 65 and 119-bottom left), Claudio Giovenzana – www.longwalk.it/Wikimedia Commons/adapted (pages 97 and 125-bottom right), Don Graham/Flickr/adapted (pages 103 and 127-top left), Antony Grossy/Wikimedia Commons/adapted (pages 59 and 118-top right), Alan Huett/Flickr/adapted (pages 75 and 121-bottom left), Brocken Inaglory/Wikimedia Commons/adapted (pages 30 and 112-top middle), Ryan Johnston/Flickr/adapted (pages 35 and 113-top right), Karelj/Wikimedia Commons/adapted (pages 31 and 112-top right), Vanessa Lollipop/Flickr/adapted (pages 106 and 127-top right), Marksykes/Fotolia/Flickr/adapted (pages 104 and 127-top right), Masur/Wikimedia Commons/adapted (pages 27 and 111-bottom left), Cumba Meillandina/public domain (pages 66 and 119-bottom middle), NASA (pages 36 and 113-bottom), NASA/Terry Virts/Flickr/adapted (pages 32 and 112-bottom left), Jo Oh/Wikimedia Commons/adapted (pages 56 and 117-bottom middle), John O'Neil/Wikimedia Commons/adapted (pages 25 and 111-top middle), Nickandmel2006/Wikimedia Commons/adapted (pages 26 and 111-top right), Oregon State University/Flickr/adapted (pages 105 and 127-bottom left), Dave Pape/public domain (pages 62 and 118-bottom right), Self/Wikimedia Commons/adapted (pages 96 and 125-bottom left), Dana Spiegel/Flickr (pages 72 and 120-bottom right), Paul Stephenson/Flickr/adapted (pages 71 and 120-bottom middle), Eric Tessmer/Flickr/adapted (pages 99 and 126-top middle), Jarek Tuszynski/Wikimedia Commons/adapted (pages 34 and 113-top left), Unknown/public domain (pages 60, 70, 74, 98, 118-bottom left, 120-bottom left, 121-top right, and 126-top left), Ed Uthman/Flickr/adapted (pages 57 and 117-bottom right), Rod Waddington/Wikimedia Commons/adapted (pages 100 and 126-top right), and Berit Watkin/Flickr/adapted (pages 29 and 112-top left)